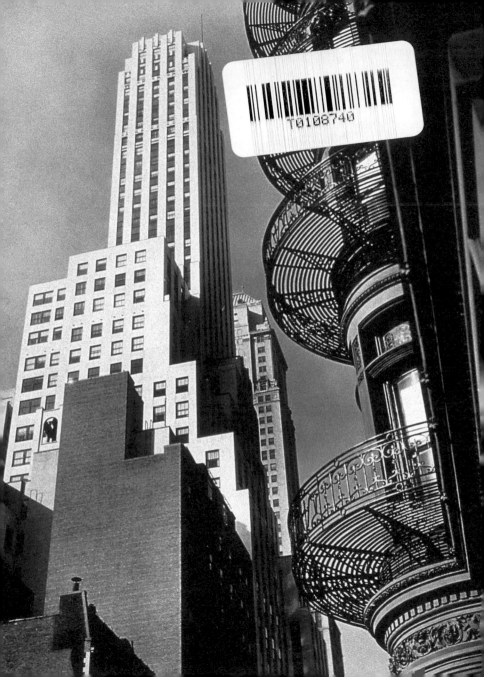

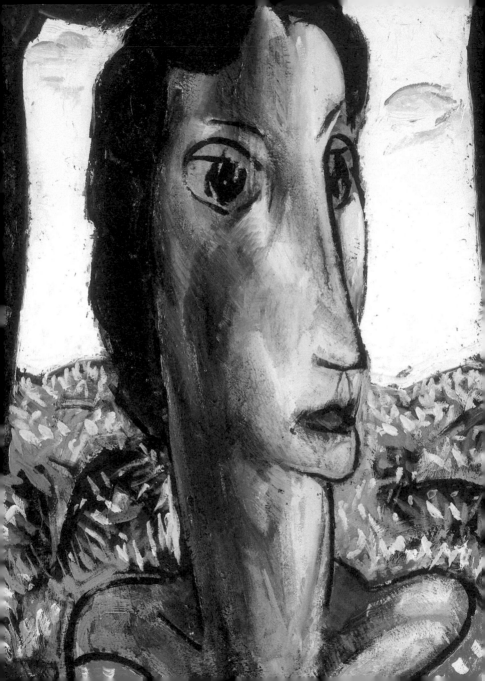

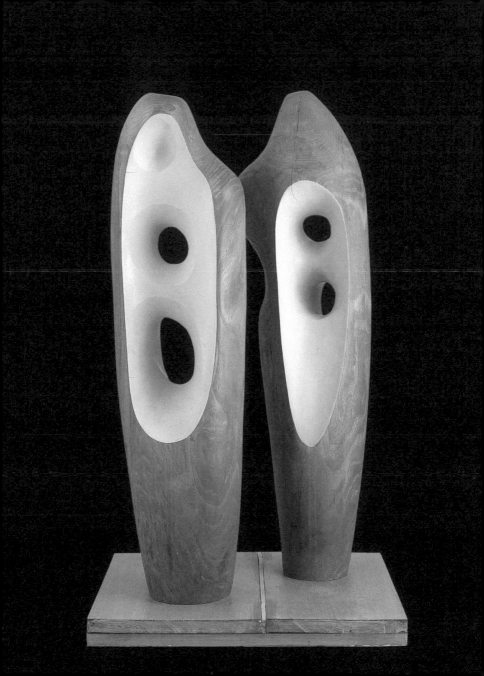

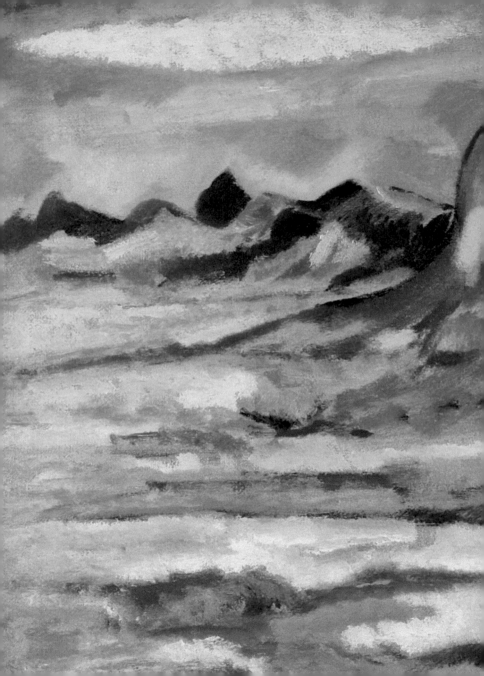

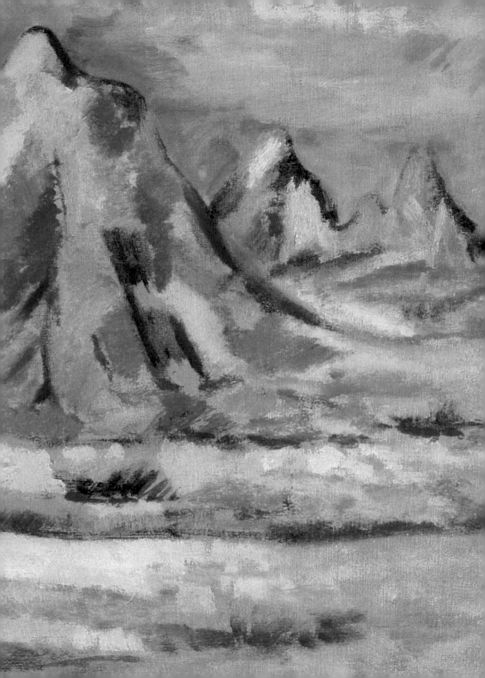

Uɴɪᴠᴇʀsɪᴛʏ ᴏғ Mɪɴɴᴇsᴏᴛᴀ

FREDERICK R. WEISMAN
ART MUSEUM, MINNEAPOLIS

DISTRIBUTED BY THE
UNIVERSITY OF MINNESOTA PRESS

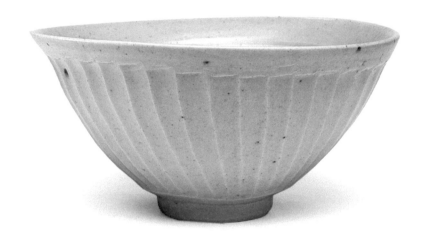

WEISMAN ART MUSEUM
THE COLLECTION

BUILDING A COLLECTION

In 1934, University of Minnesota president Lotus Coffman set aside some unused rooms in the attic of Northrop Auditorium – a classical-style building in the center of the East Bank campus – for the Little Gallery. He could hardly have imagined that his vision would one day become the Frederick R. Weisman Art Museum, a shiny "ice palace that doesn't melt" designed by internationally known architect Frank O. Gehry on the banks of the Mississippi River.

This book isn't a complete reference to the Weisman's collection. Instead, it is more like a postcard set of images of works of art that museum audiences have loved or scholars have deemed important. Highlighted here are a few stories about the extraordinary people whose dreams and risks shaped the university's art collection.

The first remarkable individual was President Lotus Coffman, who founded the museum during the darkest days of the Great Depression. He wrote to Dr. F. P. Keppel of the Carnegie Corporation in 1934, and described how he had grown up in rural Indiana without music or art. Coffman believed that the university had an obligation to "send our students away from the University as unconscious missionaries for a better civilization.... There is a need for new values to sustain the morale of individuals in the days ahead. The arts are a source for such values and I want this University to play a leading part in instilling them." A museum on campus was part of Coffman's scheme, so he put up money and space and started one. Coffman's assistant, Malcolm Willey, was a force in his own right. Willey had commissioned Frank Lloyd Wright to design his residence in the Prospect Park area of Minneapolis near the university campus. Willey knew his way around the art world and

was the constant confidant of Coffman as he began to realize his vision for a little art museum on campus that he envisioned as central to the education of students.

Coffman and Willey appointed Hudson Walker, young man about town and grandson of the founder of the Walker Art Center in Minneapolis, as the first curator and director (and only staff member) of the Little Gallery. Walker financed the first year's exhibitions mostly out of his own pocket, and when he departed to make his reputation, if not fortune, in New York as an art dealer, Walker advocated to Coffman and Willey that the university should have an art collection, not just temporary exhibitions. A collection would provide "anchorage," Walker recommended. He wrote that the university should not try to imitate the well-established Minneapolis Institute of Arts by creating a general collection — an encyclopedia of world art — but should focus on an area not familiar to students and not well represented in other public collections; he suggested contemporary American art. Walker was a dealer for a short time, but primarily he was a patron and friend to American artists. Though he never lived in Minnesota after the mid-1930s, he did not forget the gallery and his advice. Upon Walker's death in 1976, the American art collection he had formed with his wife, Ione, was bequeathed to the university, adding more than 1,200 pieces to the collection.

Marsden Hartley was one of the artists Walker represented and later befriended. Walker once traded a Hartley painting for a set of false teeth for the artist, who died in relative poverty in 1943. In the 1990s, Robert Hughes, art critic for *Time* magazine, labeled Hartley "the most brilliantly gifted" of all the American modernists. Because Hudson Walker was loyal

to artists, and didn't forget his roots in Minneapolis, the Weisman now owns the largest single collection of Hartley paintings and is the only museum in the world that could show a complete retrospective of his works. Marsden Hartley is now considered in the top rank of American artists of the twentieth century.

After Walker left the Little Gallery, Willey and Coffman looked around for a likely candidate to keep their museum running — and they found Ruth Lawrence. She was not an art historian or even a career woman; she was a housewife, mother, and hostess for her husband, one of the university's vice presidents. After her husband's suicide, the university felt the need to provide Lawrence with some means of support and, after debating whether she should be a student counselor or the art museum director, offered her the latter position. She was a brilliant choice as the museum's next leader.

Lawrence became a fearless adventurer and advocate for the museum. President Coffman and Malcolm Willey (the "Dads," as she called them) gamely financed "Ruthie's" monthlong trips to New York, and she introduced both of them to Georgia O'Keeffe and O'Keeffe's husband, Alfred Stieglitz. She persuaded Coffman and Willey to put up funds to purchase American paintings from Stieglitz, an eminent photographer and champion of those artists who were bringing ideas into America about what it meant to be a "modern" artist. Lawrence became a confidant to Stieglitz, and he wrote to her details of O'Keeffe's health problems and spoke affectionately of "our experiment," as he called the collection of the University of Minnesota.

The best-loved and most-traveled works at the Weisman are undoubtedly the two paintings by Georgia O'Keeffe. They belong to the university because of this extraordinary relationship Ruth Lawrence formed with Stieglitz and O'Keeffe. President Coffman confided to Willey that he didn't understand the O'Keeffe paintings, and he jokingly suggested, "Sometime buy a picture

of a pasture, with a brook and some cows – just for me!" But he graciously supported the purchase of works by John Marin and Arthur Dove – not exactly cows in a meadow.

In 1938 Lyonel Feininger's first retrospective in America was held at the university's art museum, and Ruth Lawrence selected Feininger's *Dröbsdorf I* to purchase from this show. That was the last painting she bought with university funds. The death of President Coffman late that year was likely a factor in the termination of university funding for art, and it was the end of an era for the art collection at the university. Since then, the collection has grown by gifts and bequests from many supportive friends, but not by major purchases.

In 1929, University of Minnesota professor Alfred Jenks was supported by the Minneapolis Institute of Arts to excavate a southwestern New Mexico village of the Mimbres people, an ancient Native American culture. Between 1929 and 1931 these excavations, primarily at a site called Galaz in the Mimbres River Valley, yielded more than eight hundred ceramic bowls from 1000–1130/50 A.D. They were transferred to the museum in 1993 from the Department of Anthropology, and since then these lively and incredibly contemporary-looking works of art have been the subject of publications, exhibitions, and intensive research. The museum has one of the two largest collections of Mimbres material in the world.

Ceramic artist Warren MacKenzie, who was on the university's art faculty from 1953 to 1990, used the museum's collection constantly in his teaching. With his wife, Nancy, he has donated not only his own artwork but that of leading ceramic artists from around the world, making ceramics, along with American modernism, a significant feature of the Weisman's collection.

Frederick R. Weisman gave the museum an installation by Edward and Nancy Reddin Kienholz, *Pedicord Apartments,* which is a particular favorite

of politicians and Girl Scouts. The narrow dark corridor of a run-down apartment building in Spokane, Washington, transformed by the artists into an environmental artwork, reminds them, they report, of door-to-door campaigning and selling cookies!

When the museum moved to its new building in 1993, two giant works of pop art were rediscovered. These murals, painted for the 1964 New York World's Fair by James Rosenquist and Roy Lichtenstein, were given to the university by the artists a few years after the fair. At that time the museum had no walls large enough to show them, but the university did have a lot of brick buildings; because these paintings had been shown outdoors in New York, perhaps they were intended to cover some of that exterior brick expanse. Fortunately that never happened: Minnesota's climate would have ensured that the murals would no longer exist. Now a laughing redhead, typical of Lichtenstein's comic-book style, welcomes each visitor who enters the Weisman's front door. Rosenquist's collage-like painting of Uncle Sam's top hat and other symbols of American consumerism and pride attracts a glance from every student who walks past the museum's large gallery windows on the way to the next-door student union — aptly named after Lotus Coffman, who began it all.

LYNDEL KING
DIRECTOR AND CHIEF CURATOR
WEISMAN ART MUSEUM

PLATES

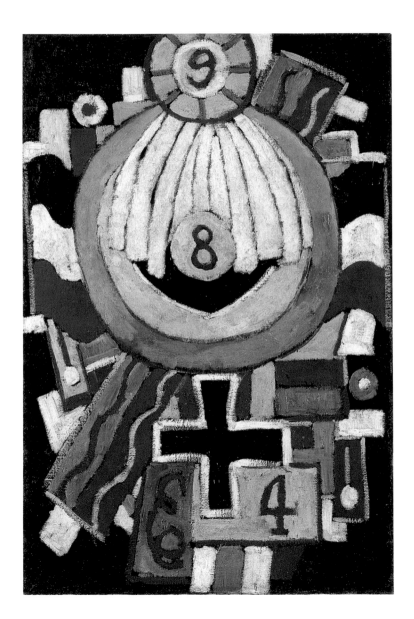

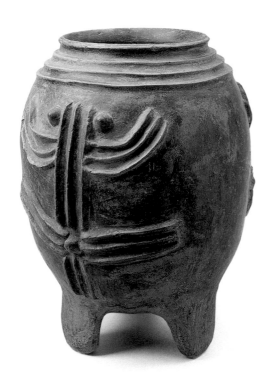

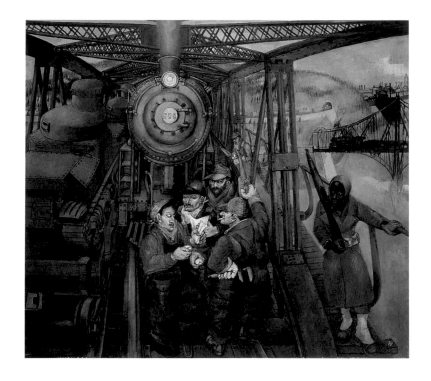

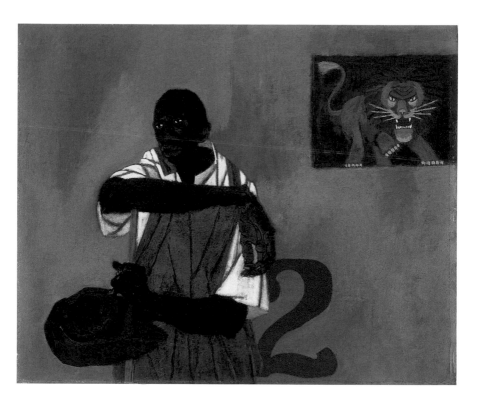

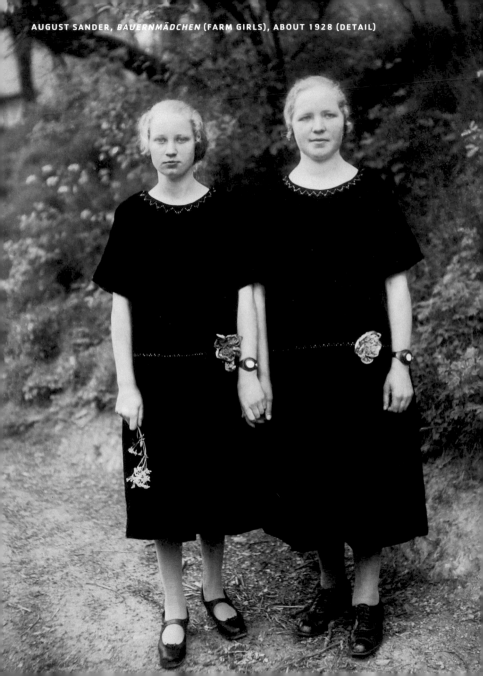

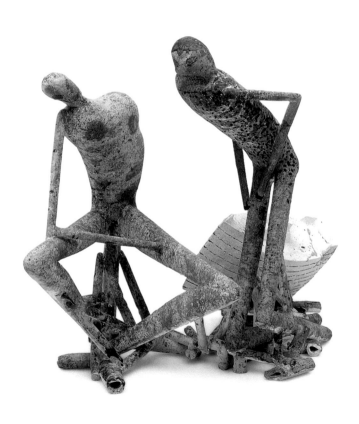

B. J. O. NORDFELDT, *SEATED NEW MEXICAN WITH LIGHT BLUE COAT*, ABOUT 1928

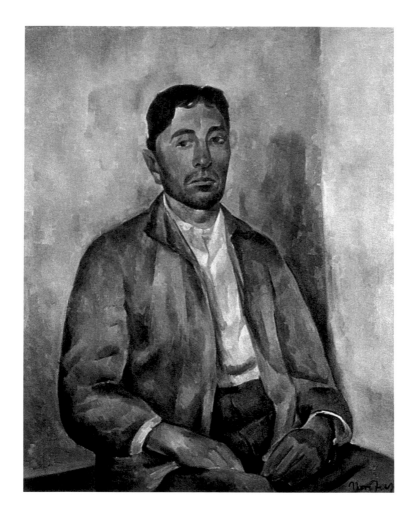

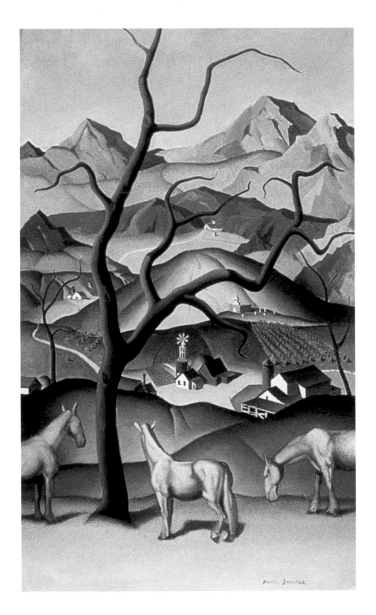

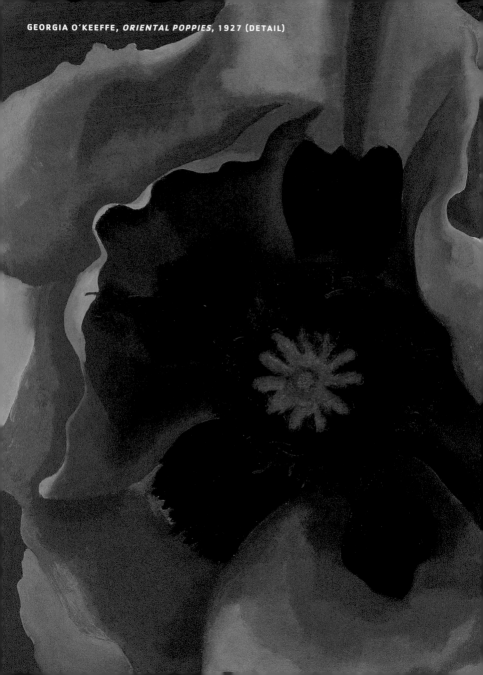

GEORGIA O'KEEFFE, *ORIENTAL POPPIES*, 1927 (DETAIL)

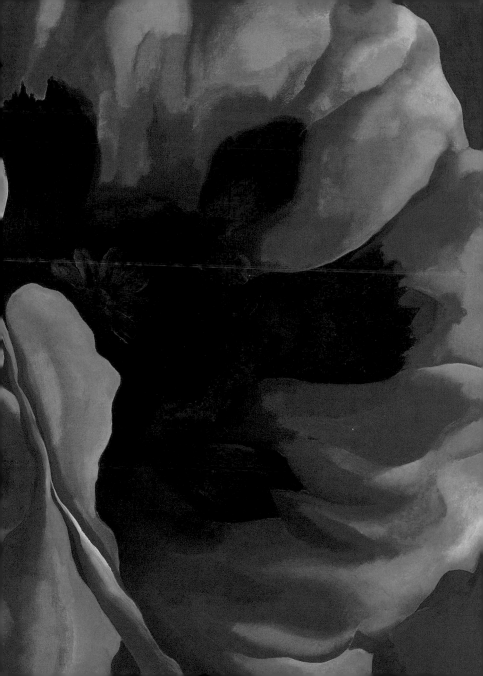

ALBERT BIERSTADT, *MINNEHAHA FALLS*, 1886

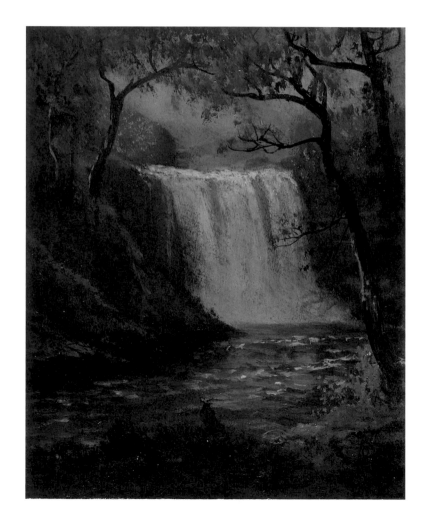

THE VITALITY OF A GREAT UNIVERSITY WILL COME MORE FROM O'KEEFFES AND MARINS THAN FROM TRUCKS.

MALCOLM WILLEY TO ALFRED STIEGLITZ, COMMENTING
ON UNIVERSITY PRIORITIES, JULY 26, 1935

THE VITALITY OF A GREAT UNIVERSITY
WILL COME MORE FROM O.'KEEFFES AND
MARINS THAN FROM TRUCKS.

MALCOLM WILLEY TO ALFRED STIEGLITZ, COMMENTING
ON UNIVERSITY PRIORITIES, JULY 26, 1935

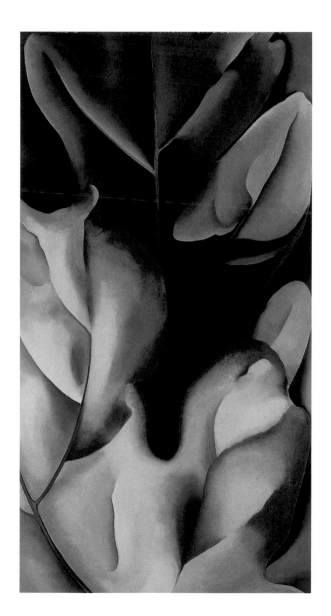

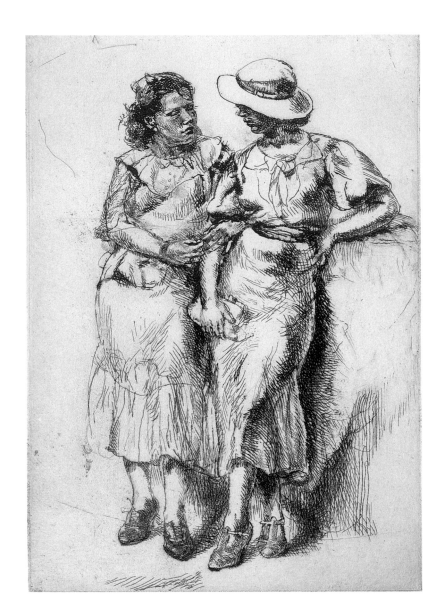

ALFRED MAURER, *GIRL IN WHITE*, ABOUT 1901

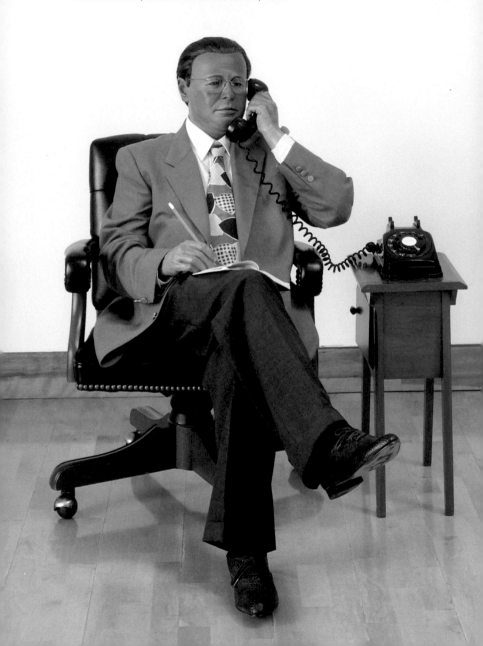

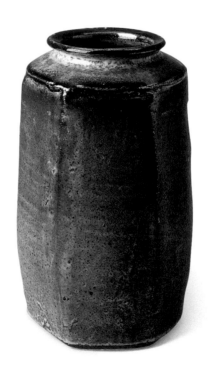

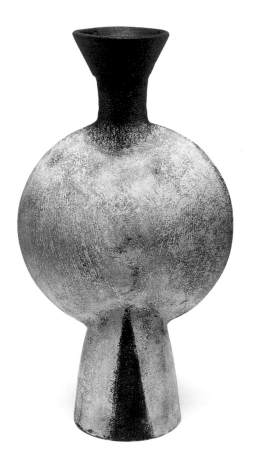

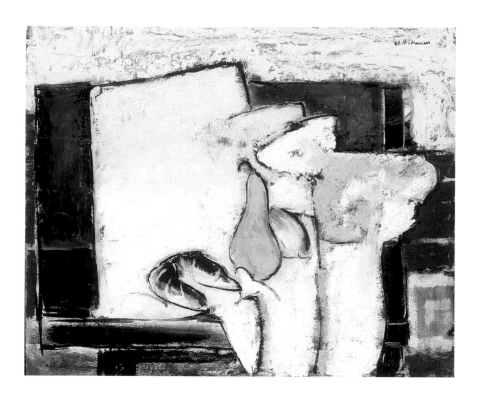

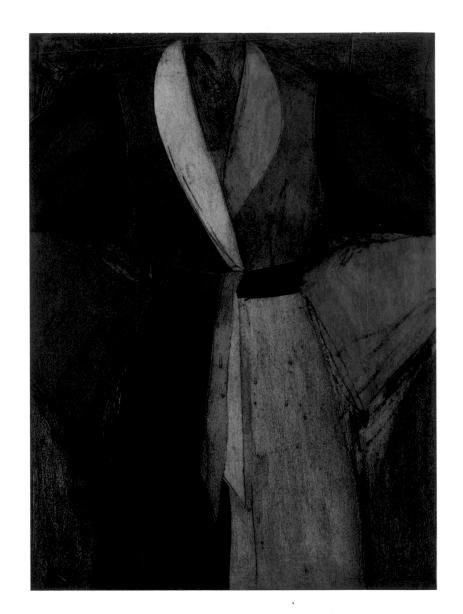

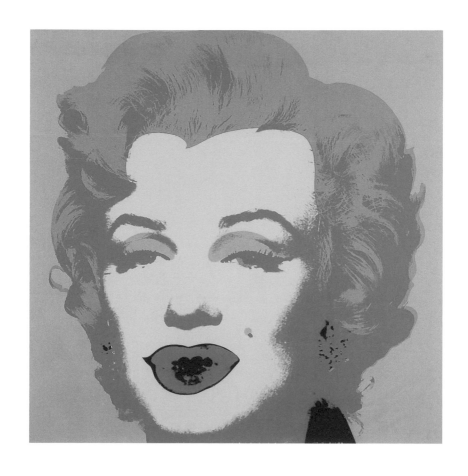

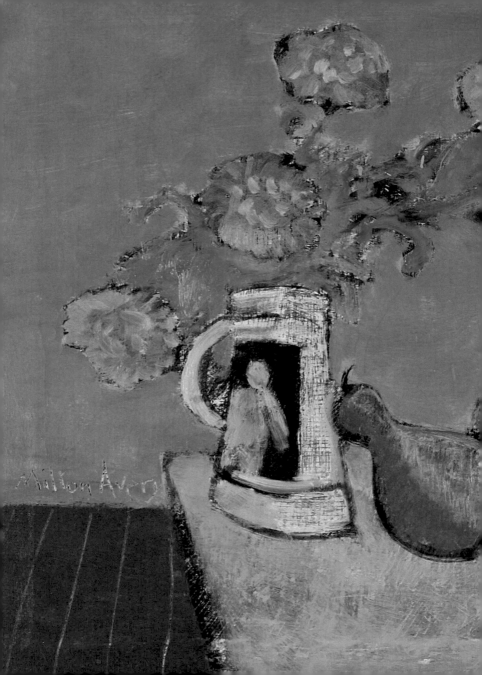

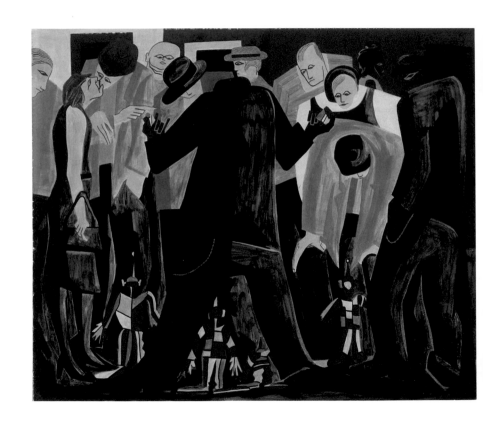

A UNIVERSITY COLLECTION SHOULD HAVE A WORKSHOP CHARACTER

AS OPPOSED TO MOST PEOPLE'S NOTION OF A MUSEUM AS A PLACE FOR THE SAFEKEEPING OF RARE OBJECTS.

HUDSON WALKER MEMO TO MALCOLM WILLEY, 1934

A UNIVERSITY COLLECTION SHOULD
HAVE A WORKSHOP CHARACTER

AS OPPOSED TO MOST PEOPLE'S NOTION OF
A MUSEUM AS A PLACE FOR THE SAFEKEEPING
OF RARE OBJECTS.

HUDSON WALKER MEMO TO MALCOLM WILLEY, 1934

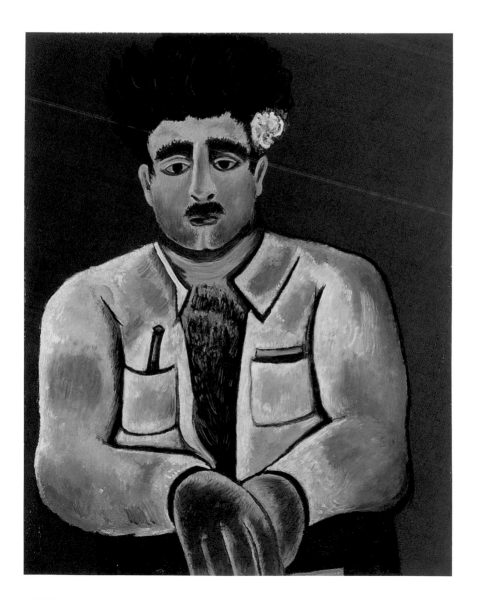

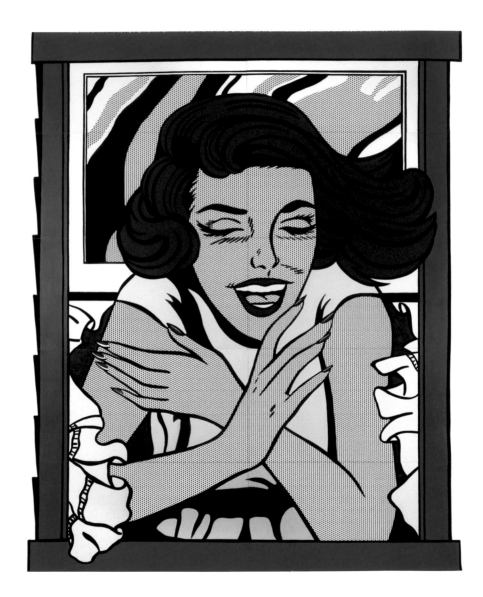

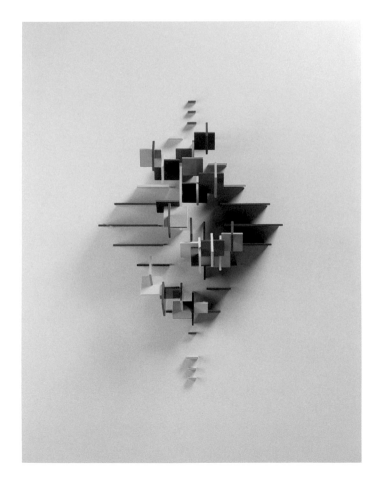

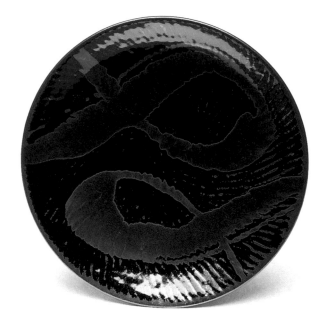

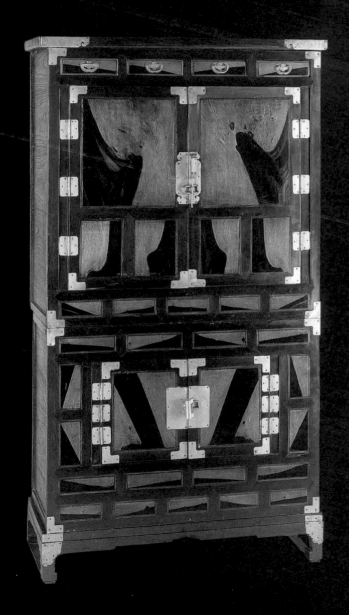

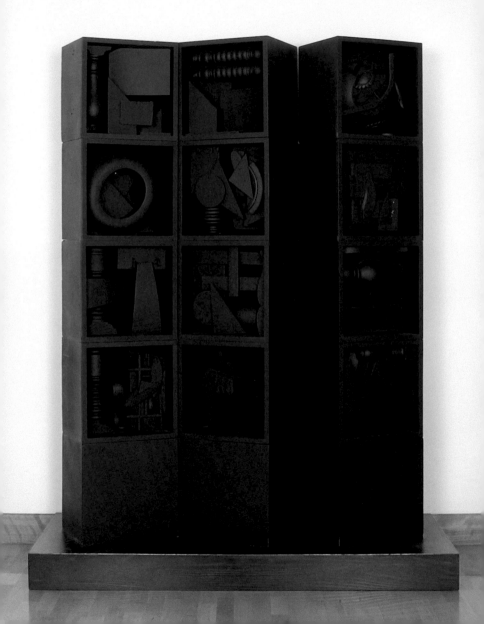

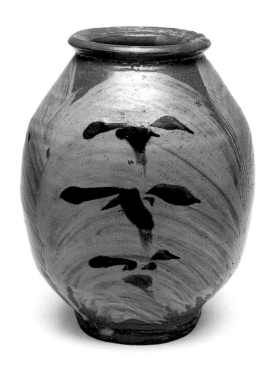

ROBERT MOTHERWELL, *MURAL FRAGMENT*, 1950 (DETAIL)

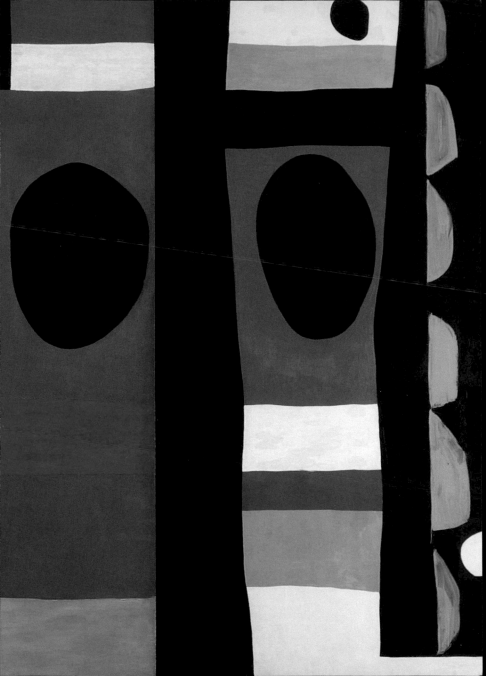

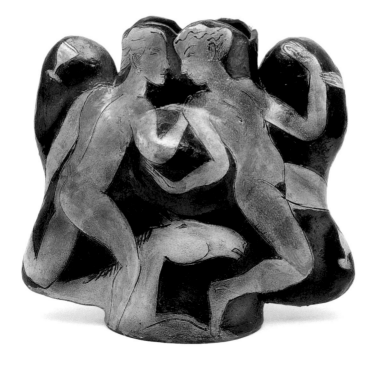

MAX BECKMANN, *STILLEBEN MIT FISCHEN UND PAPIERBLUME*
(STILL LIFE WITH FISH AND PINWHEEL), 1923

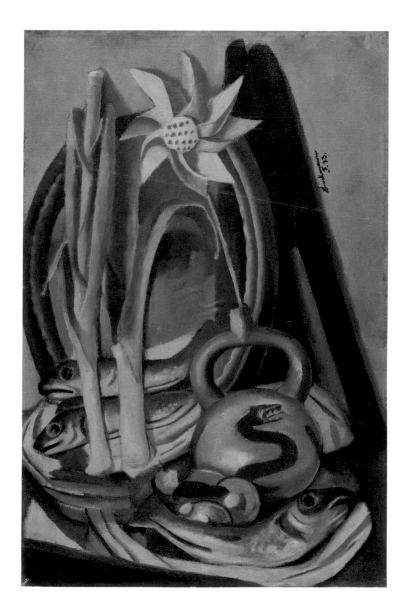

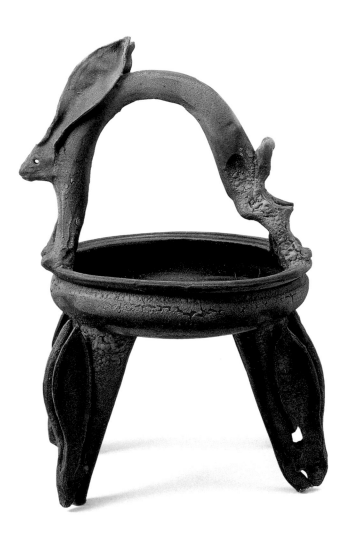

MIMBRES ART EXPRESSES THE TENSIONS
AND BEAUTY OF AN ANCIENT WAY OF LIFE.

WE ASK HOW AN ART CREATED TO
SERVE SO SMALL A SOCIETY CAN
SPEAK SO DIRECTLY TO OUR RADICALLY
DIFFERENT WORLD.

DR. JERRY BRODY, PROFESSOR EMERITUS, UNIVERSITY OF NEW MEXICO,
FOR THE WEISMAN ART MUSEUM EXHIBIT *TO TOUCH THE PAST*, 1996

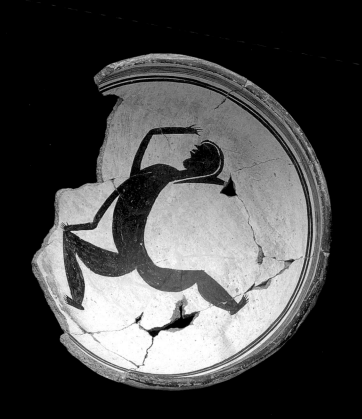

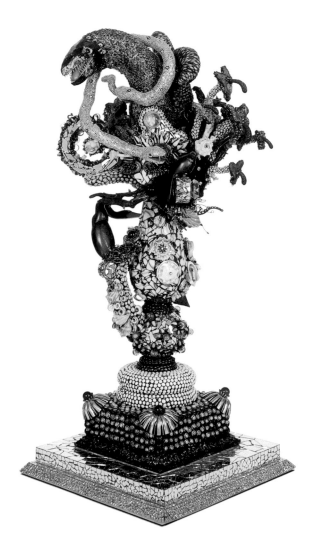

EDWARD KIENHOLZ AND NANCY REDDIN KIENHOLZ,
PEDICORD APTS., 1982–83

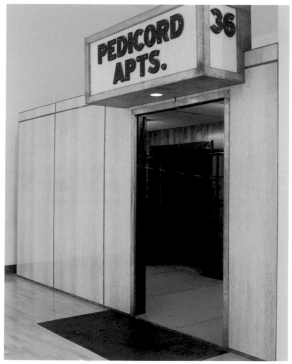

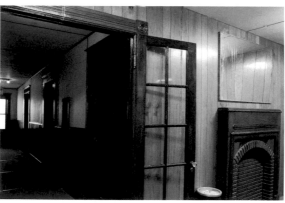

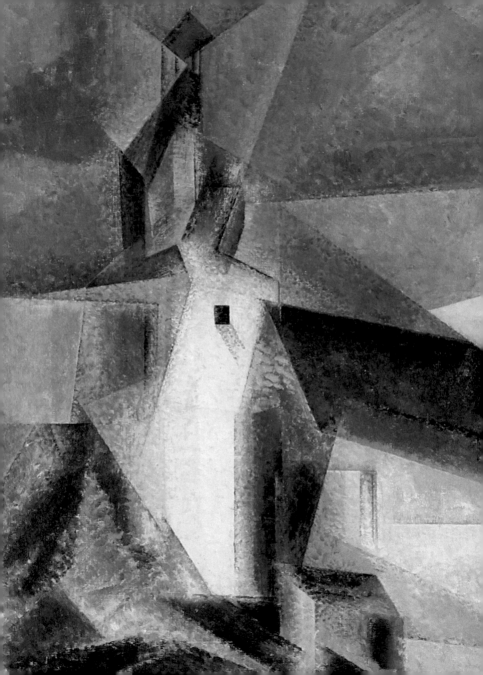

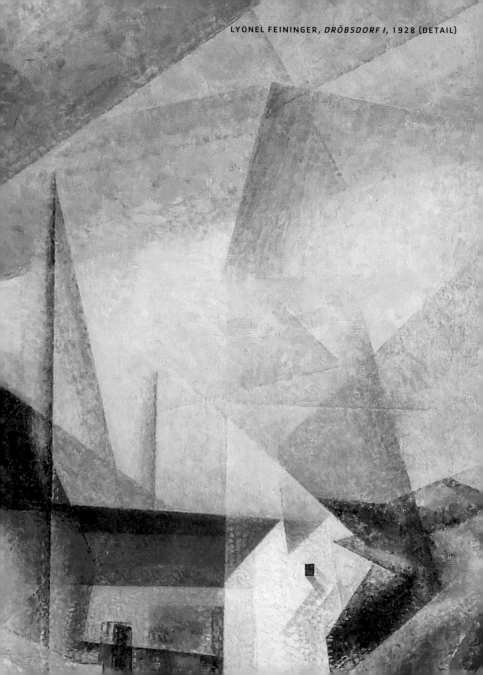

EDWARD HOPPER, *NIGHT SHADOWS*, 1921

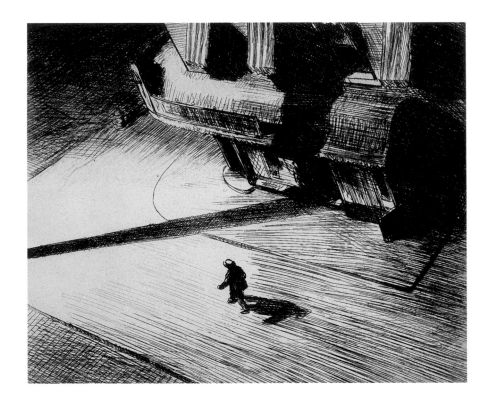

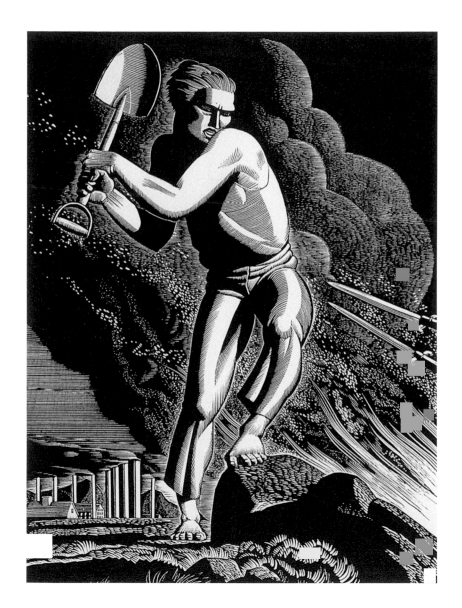

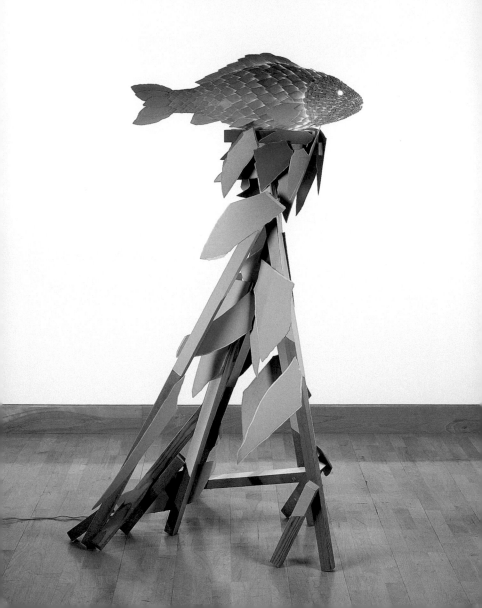

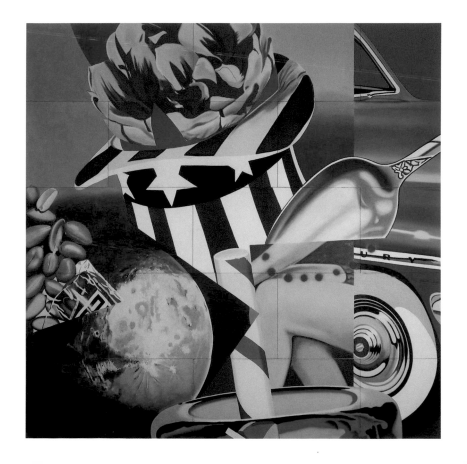

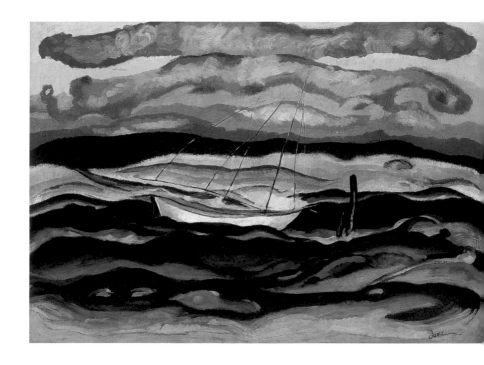

JOHN MARIN, *THE SEA AND PERTAINING THERETO*, 1921

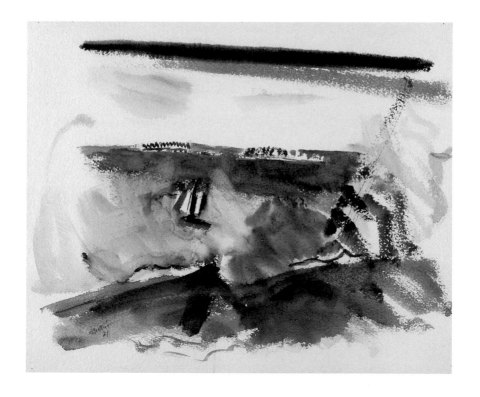

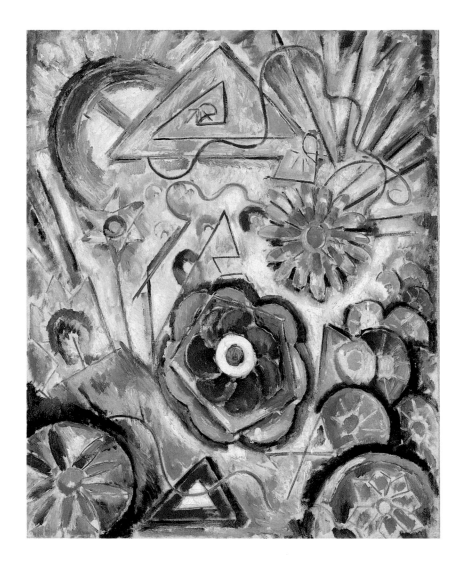

... FIREFLIES WITH TINY INTERNAL GENERATORS AND STARS DANGLING FROM SOLAR STRINGS ABOVE YOUR HEAD ...

FROM THE POEM "STAR CAGE" BY AMBER SEIFERT,
ARTWORDS CONTEST, UNDERGRADUATE WINNER, 2000

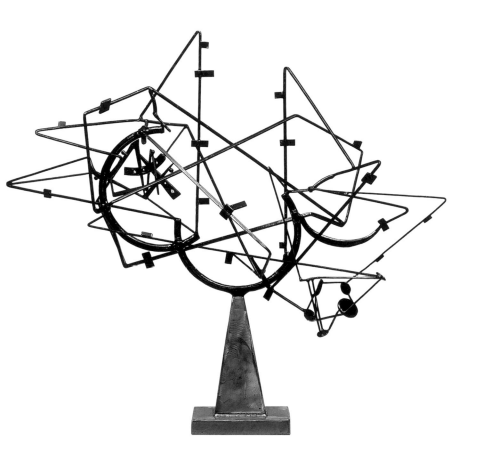

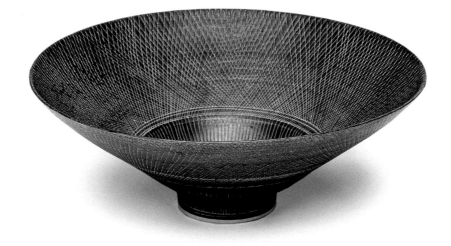

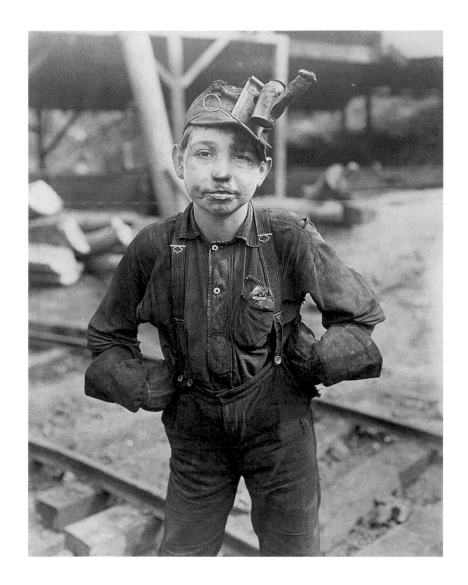

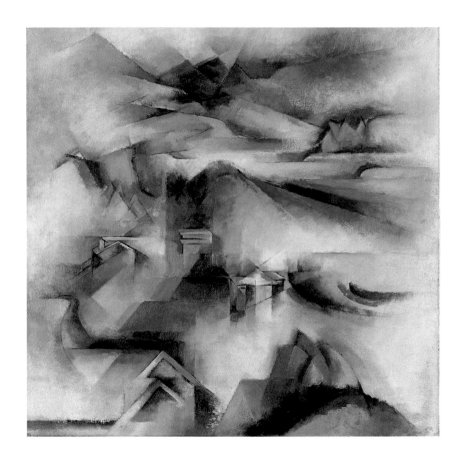

THE COLLECTION CREDITS

Dimensions are given in inches and centimeters; height precedes width, followed by depth or diameter. For works on paper, dimensions reflect image size.

Berenice Abbott

(American, 1898–1991)

Murray Hill Hotel: Spiral, 112 Park Avenue, Manhattan, 1935
Gelatin silver print
9 $^{7}/_{16}$ x 7 $^{1}/_{4}$ in. (24 x 18.4 cm)
Museum purchase
1939.33

Rudy Autio

(American, born 1926)

Dance Hall, 1997
Glazed ceramic
25 $^{1}/_{4}$ x 28 x 16 $^{1}/_{2}$ in. (64.1 x 71.1 x 41.9 cm)
The Nancy and Warren MacKenzie Fund
1997.30

Milton Avery

(American, 1885–1965)

Still Life, 1935–39
Oil on canvas
27 $^{3}/_{4}$ x 36 $^{1}/_{2}$ in. (70.5 x 92.7 cm)
Bequest of Hudson D. Walker from the Ione and Hudson D. Walker Collection
1978.21.28

Max Beckmann

(German, 1884–1950)

Stilleben mit Fischen und Papierblume (Still Life with Fish and Pinwheel), 1923
Oil on canvas
23 $^{7}/_{8}$ x 15 $^{15}/_{16}$ in. (60.6 x 40.5 cm)
Gift of Ione and Hudson D. Walker
1953.288

Charles Biederman

(American, born 1906)

#9, Turner, designed 1977, created 1979
Painted aluminum
42 x 32 $^{1}/_{2}$ x 11 $^{3}/_{4}$ in. (106.7 x 82.6 x 29.8 cm)
Promised gift of Charles Biederman
L 1998.39.237

Albert Bierstadt

(American, 1830–1902)

Minnehaha Falls, 1886
Oil on wood panel
6 $^{1}/_{4}$ x 5 $^{1}/_{8}$ in. (15.9 x 13 cm)
Gift of Ione Walker
1978.25.1

Isabel Bishop

(American, 1902–1988)

Noon Hour, 1935
Etching on paper
6 $^{15}/_{16}$ x 4 $^{13}/_{16}$ in. (17.6 x 12.2 cm)
Gift of Walter Library, University of Minnesota
1965.28.7

Robert Brady

(American, born 1946)

Pontchartrain, 1986
White stoneware with vitreous slip and staining
32 x 30 x 27 in. (81.3 x 76.2 x 68.6 cm)
The Nancy and Warren MacKenzie Fund
1996.2a,b

Hans Coper
(English, 1920–1981)

Flat bottle, about 1950
Iron-glazed stoneware
16 ½ x 9 ⅛ x 4 ¼ in. (41.9 x 23.2 x 10.8 cm)
Museum purchase
1957.290

Jim Dine
(American, born 1935)

Very Picante, 1995
Cardboard relief and cardboard intaglio
on paper
53 x 38 ⅞ in. (134.6 x 98.7 cm)
Gift of Kim and Gloria Anderson
2000.56.1

Arthur Dove
(American, 1880–1946)

Gale, 1932
Oil on canvas
25 ¾ x 35 ¾ in. (65.4 x 90.8 cm)
Museum purchase
1936.84

Philip Evergood
(American, 1901–1973)

Wheels of Victory, 1944
Oil on panel
37 ¾ x 42 ½ in. (95.9 x 108 cm)
Bequest of Hudson D. Walker from the
Ione and Hudson D. Walker Collection
1978.21.830

Lyonel Feininger
(American, 1871–1956)

Dröbsdorf I, 1928
Oil on canvas
32 ¼ x 40 ⅛ in. (81.9 x 101.9 cm)
Museum purchase
1939.97

Ken Ferguson
(American, born 1928)

Hare Handle Basket with Four Legs, 1995
Glazed stoneware
25 ½ x 17 x 17 in. (64.8 x 43.2 x 43.2 cm)
The Nancy and Warren MacKenzie Fund
1996.17

Frank Gehry
(American, born 1929)

Fish Lamp, about 1985
Wood and Formica
69 ½ x 30 x 38 ½ in. (176.5 x 76.2 x 97.8 cm)
Gift of Mike and Penny Winton
1990.10

Robert Gwathmey
(American, 1903–1988)

Nobody Around Here Calls Me Citizen, 1943
Oil on canvas
14 ⅛ x 17 ⅛ in. (35.9 x 43.5 cm)
Bequest of Hudson D. Walker from the
Ione and Hudson D. Walker Collection
1978.21.34

Shoji Hamada
(Japanese, 1894–1978)

Vase, 1935
Wood-fired stoneware
8 ⅞ x 6 ½ in. (22.5 x 16.5 cm)
Promised gift of Nancy and Warren MacKenzie
L2003.26.1

Duane Hanson
(American, 1925–1996)

Executive in Red Chair, 1988
Painted bronze with mixed media
44 ½ x 30 x 52 in. (113 x 76.2 x 132.1 cm)
Gift of the Frederick Weisman Company
2000.24.3a-p

Marsden Hartley
(American, 1877–1943)

Abstraction with Flowers, 1913
Oil on canvas
39 ½ x 31 ⅞ in. (100.3 x 81 cm)
Bequest of Hudson D. Walker from the
Ione and Hudson D. Walker Collection
1978.21.243

*Adelard the Drowned, Master of the
"Phantom,"* about 1938–39
Oil on academy board
27 ⅞ x 22 in. (70.8 x 55.9 cm)
Bequest of Hudson D. Walker from the
Ione and Hudson D. Walker Collection
1978.21.236

New Mexico Landscape, 1919
Oil on canvas
18 ¼ x 24 ¼ in. (46.4 x 61.6 cm)
Bequest of Hudson D. Walker from the
Ione and Hudson D. Walker Collection
1978.21.235

Portrait, about 1914–15
Oil on canvas
32 ¼ x 21 ½ in. (81.9 x 54.6 cm)
Bequest of Hudson D. Walker from the
Ione and Hudson D. Walker Collection
1978.21.234

Barbara Hepworth
(English, 1903–1975)

Two Figures, 1947–48
Painted elm wood
40 x 23 x 23 in. (101.6 x 58.4 x 58.4 cm)
The John Rood Sculpture Collection
1962.12

Lewis Hine
(American, 1874–1940)

Young Boy Coal Miner, 1909–13
Gelatin silver print
13 ⅝ x 10 ¹¹⁄₁₆ in. (34.6 x 27.1 cm)
Gift of the Scandinavian Language
Department, University of Minnesota
1962.6.16

Edward Hopper
(American, 1882–1967)

Night Shadows, 1921
Etching on paper
7 x 8 ⁵⁄₁₆ in. (17.8 x 21.1 cm)
The Nordfeldt Fund
1981.10.1

Rockwell Kent
(American, 1882–1971)

Workers of the World Unite!, 1937
Wood engraving on paper
5 ⅞ x 7 ⅞ in. (14.9 x 20 cm)
The Frederick R. Weisman Art
Museum collection
1938.47

Edward Kienholz
(American, 1927–1994)
Nancy Reddin Kienholz
(American, born 1943)

Pedicord Apts., 1982–83
Mixed media
120 x 192 ¾ x 445 ½ in.
(304.8 x 489.6 x 1131.6 cm)
Gift of the Frederick R. Weisman Art
Foundation
1999.18

Jacob Lawrence
(American, 1917–2000)

Dancing Doll, 1947
Egg tempera on hardboard
20 ¼ x 24 ⅛ in. (51.4 x 61.3 cm)
Bequest of Hudson D. Walker from the
Ione and Hudson D. Walker Collection
1978.21.288

Bernard Leach
(English, 1887–1979)

Bowl, about 1953–54
Glazed porcelain
4 x 7 ⅞ x 7 ⅞ in. (10.2 x 20 x 20 cm)
Promised gift of Nancy and Warren
MacKenzie
L2003.26.2

Roy Lichtenstein
(American, 1923–1997)

World's Fair Mural, 1964
Oil on plywood
240 x 192 in. (609.6 x 487.7 cm)
Gift of the artist
1968.7

Stanton Macdonald-Wright
(American, 1890–1973)

Cañon Synchromy (Orange), 1919
Oil on canvas
24 ⅛ x 24 ⅛ in. (61.3 x 61.3 cm)
Gift of Ione and Hudson D. Walker
1973.19

Warren MacKenzie
(American, born 1924)

Vase, about 1985
Glazed stoneware
12 ¾ x 8 x 8 in. (32.4 x 20.3 x 20.3 cm)
Gift of Nancy and Warren MacKenzie
1999.21.111

John Marin
(American, 1870–1953)

The Sea and Pertaining Thereto, 1921
Watercolor over charcoal on paper
16 ³⁄₁₆ x 19 ⁷⁄₁₆ in. (41.1 x 49.4 cm)
Museum purchase
1936.56

Alfred Maurer
(American, 1868–1932)

Girl in White, about 1901
Oil on wood panel
24 x 19 ⅜ in. (61 x 49.2 cm)
Gift of Ione and Hudson D. Walker
1953.307

Head of a Girl, 1929
Oil on cloth on composition board
21 ½ x 18 ⅛ in. (54.6 x 46 cm)
Gift of Ione and Hudson D. Walker
1953.315

Alfred Maurer
(American, 1868–1932)

Yellow Pear and Roll, about 1920
Oil on composition board
18 ⅛ x 21 ¾ in. (46 x 55.2 cm)
Gift of Ione and Hudson D. Walker
1953.305

Robert Motherwell
(American, 1915–1991)

Mural Fragment, 1950
Oil on composition board
96 x 144 in. (243.8 x 365.8 cm)
Gift of Katherine Ordway
1952.17

Louise Nevelson
(American, 1900–1988)

Silent Music VII, 1964
Painted wood
57 x 50 x 12 in. (144.8 x 127 x 30.5 cm)
Gift of Julie and Babe Davis
1999.16a-o

B. J. O. Nordfeldt
(American, 1878–1955)

Seated New Mexican with Light Blue Coat,
about 1928
Oil on canvas
36 x 29 ¼ in. (91.4 x 74.3 cm)
Gift of Mrs. Emily Abbott Nordfeldt
1976.1

Georgia O'Keeffe
(American, 1887–1986)

Oak Leaves, Pink and Gray, 1929
Oil on canvas
33 ⅛ x 18 in. (84.1 x 45.7 cm)
Museum purchase
1936.85

Oriental Poppies, 1927
Oil on canvas
30 x 40 ⅛ in. (76.2 x 101.9 cm)
Museum purchase
1937.1

Judy Onofrio
(American, born 1939)

Big Catch, 1996
Ceramic, wood, shell, glass, paint, and metal
74 x 34 ½ x 27 ½ in. (188 x 87.6 x 69.9 cm)
The Nancy and Warren MacKenzie Fund
1997.28a-l

Lucie Rie
(English, 1902–1995)

Bowl, early twentieth century
Glazed porcelain
3 ⅛ x 8 ¼ x 8 ¼ in. (7.9 x 21 x 21 cm)
Museum purchase
1957.297

James Rosenquist
(American, born 1933)

World's Fair Mural, 1963–64
Oil on Masonite
240 x 240 in. (609.6 x 609.6 cm)
Gift of the artist
1968.8

Paul Sample
(American, 1896–1974)

Western Landscape, 1930–38
Oil on canvas
30 ⅛ x 18 ¼ in. (76.5 x 46.4 cm)
Museum purchase
1936.89

August Sander
(German, 1876–1964)

Bauernmädchen (Farm Girls), about 1928
Gelatin silver print
9 ¾ x 7 in. (24.8 x 17.8 cm)
Gift of Martin Weinstein
2001.39.3

Tatsuzo Shimaoka
(Japanese, born 1919)

Platter, 2000
Wood-fired, glazed stoneware
2 ¼ x 12 ¼ x 12 ¼ in. (5.7 x 31.1 x 31.1 cm)
The Nancy and Warren MacKenzie Fund
2001.37

David Smith
(American, 1906–1965)

Star Cage, 1950
Painted metal
44 ⅞ x 51 ¼ x 25 ¾ in.
(114 x 130.2 x 65.4 cm)
The John Rood Sculpture Collection
1953.189

Andy Warhol
(American, 1928–1987)

Marilyn, 1967
Screenprint on paper
36 x 36 in. (91.4 x 91.4 cm)
Gift of George Shea and Gordon Locksley,
by exchange
1988.13

Artist unknown
(African, Burkina Faso, Kurumba culture)

Vessel, early twentieth century
Earthenware
20 x 15 x 15 in. (50.8 x 38.1 x 38.1 cm)
The Reuben and Eva Brown Ceramics Fund
1999.8

Artist unknown
(Korean)

Wardrobe chest, early twentieth century,
Kyonggi Province or city of Seoul
Persimmon wood, pear wood, paulownia wood,
white brass fittings, and oil finish
66 ¾ x 37 x 16 ½ in. (169.5 x 94 x 41.9 cm)
The Edward Reynolds Wright Collection
1987.22.16a-c

Artist unknown
(Southwestern New Mexico, Mimbres culture)

Bowl, Mimbres Classic Black-on-white style
III, about 1000–1130/50 A.D.
Earthenware with slip and pigments
4 ⁵⁄₁₆ x 8 ⅞ x 7 ¹³⁄₁₆ in. (11 x 22.5 x 19.8 cm)
Transfer, Department of Anthropology,
University of Minnesota
1992.22.673

Published by Frederick R.
Weisman Art Museum
University of Minnesota
333 East River Road
Minneapolis, MN 55455
Phone: (612) 625-9494
www.weisman.umn.edu

Distributed by University
of Minnesota Press
111 Third Avenue South
Suite 290
Minneapolis, MN 55401
www.upress.umn.edu

Copyright 2004 Frederick R.
Weisman Art Museum

ISBN 0-8166-4509-4

A Cataloging-in-Publication
record for this book is
available from the Library
of Congress.

Book design by Gail Wiener

Cover: Roy Lichtenstein,
World's Fair Mural, 1964
(detail)

Cover photograph by
Norbert Marklin

Frontispiece images:
Berenice Abbott, *Murray Hill
Hotel,* 1935 (detail)

Alfred Maurer, *Head of a
Girl,* 1929 (detail)

Barbara Hepworth, *Two
Figures*, 1947–48

Marsden Hartley, *New
Mexico Landscape*,
1919 (detail)

Title page: Bernard Leach,
Bowl, about 1953–54

Printed by Shapco Printing,
Inc., Minneapolis

The Weisman Art Museum
would like to acknowledge
Bob Fogt and Peter Lee for
their photography of the
collection.